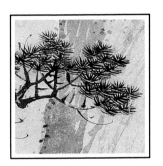

THE ART OF
CHINESE
WATERCOLOURS
Amanda O'Neill

A Compilation of Works from the
BRIDGEMAN ART LIBRARY

SIENA

The Art of Chinese Watercolours

This edition first published in Great Britain in 1995 by
Parragon Book Service Limited
Units 13-17 Avonbridge Industrial Estate
Atlantic Road
Avonmouth
Bristol BS11 9QD

ISBN 0-7525-1121-1

Printed in Italy

Editors:	Barbara Horn, Alexa Stace, Alison Stace, Tucker Slingsby Ltd and Jennifer Warner
Designers:	Robert Mathias • Pedro Prá-Lopez, Kingfisher Design Services
Typesetting/DTP:	Frances Prá-Lopez, Kingfisher Design Services
Picture Research:	Kathy Lockley

The publishers would like to thank Joanna Hartley at the Bridgeman Art Library
for her invaluable help.

CHINESE WATERCOLOURS

Watercolour painting was invented in China, more than 2,000 years ago. Fresh, free and fluid, it was the perfect medium in which to express the Chinese philosophy of life. With a tapered animal-hair brush it was possible to create visions of China's dramatic landscape, and her exotic plant and animal life, which said more than words about the harmony within nature, and man's harmonious position in the natural world.

To enter the world of Chinese watercolours, we need to leave behind a great many Western concepts about the nature of art. Chinese painting theory is inseparable from an underlying philosophy that sees a unity in all life forms. It is less concerned with the individuality of a subject than with its universality. By painting a landscape, a bird or a flower the artist is engaging in active meditation on the spirit of nature, not simply setting down what he sees.

Perhaps the best introduction to the world of Chinese watercolours was written 14 centuries ago, by the artist Hsieh Ho. His famous manual on painting theory, *Ku-hua p'in-lu*, sets out the philosophy behind the art of the East, without which we cannot hope to understand the paintings themselves. Hsieh Ho notes that the first, and most important, principle of art is the quality of liveliness. Before all else, the painter must strive to capture *ch'i*, the life-spirit of his subject. Without this 'rhythmic vitality' a painting is meaningless. Consequently, traditional Chinese painting is not about representation, although the artist may represent the outward appearance of his subject with great accuracy, nor about

interpretation. Its theme is the inner truth of its subject – the life-spirit within the outer form. As a later painter, Ching Hao (900-60), puts it: 'Resemblance reproduces the formal aspects of objects, but neglects their spirit...He who tries to transmit the spirit by the means of formal aspect and ends by merely obtaining the outward appearance, will produce a dead thing.'

But *ch'i* cannot be expressed without absolute control of the painter's tools, so next in importance is *ku*, the structural strength of brushwork. Every stroke counts: simplicity, speed and spontaneity are the mark of a master's brushstrokes. The Chinese brush, developed in Neolithic times, is a wonderfully versatile instrument with a far wider range of strokes than the softer European brush. Different effects are achieved, for example, by varying pressure, speed, moisture or the angle of the brush. But mastery of the brush demands enormous control and self-discipline.

In these two elements, *ch'i* and *ku*, lies the essence of Chinese art; but equally important, Hsieh Ho points out, are outward likeness, natural colouring and the harmonious composition of the picture as a whole. These are to be achieved, not by drawing a subject from life but by observing it, studying it, and achieving an awareness of its essence in the mind's eye, from which the painting is to be created. As a sixth principle, Hsieh Ho adds that one should learn the knowledge of earlier great artists by copying their works. This does not preclude developments over the centuries, but means that precious traditions are not to be lost, and the hard-won knowledge of the great masters is not to be wasted.

As well as having different priorities from those of the West, Chinese art employs different conventions (for example, methods of showing distance) and techniques. In fact, when Westerners first discovered Chinese paintings, they often found it hard to recognize them as art! In 1804, one English traveller reported that the Chinese were 'unable to pencil out a correct outline of many objects, to give body to the same by the application of proper lights

and shadows, and to lay on the nice shades of colour, so as to resemble the tints of nature'. It was not until later that Western eyes became educated to appreciate the beauties of China's indigenous artistic tradition. In the meantime, a school of Chinese export paintings arose to satisfy the European demand for exotica in a style acceptable to the Western market. These vary in their degree of Westernization, and in their quality.

The pieces in this book offer an introduction to the world of Chinese watercolours. They include a selection of export paintings which cover the full range of hybridization, from artistic integrity to a pair of highly commercialized pieces of tourist-bait. But they also include serene master-works a thousand years old, which sought 'to fathom the uttermost secrets of heaven and earth and illumine what is not lit by sun and moon'.

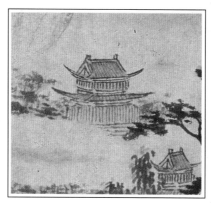

Detail

▷ **Mountain View**
Ming Dynasty (1368-1644)

CHINESE LANDSCAPE STUDIES are rarely painted from life, but constructed from the mind's eye in the studio. The artist is not concerned to make an accurate portrait of an actual scene, but to capture the essence of such places – painting the spirit, rather than the form. He seeks to depict the power of nature in lonely landscapes whose mountains, rocks and trees have been sculpted by time and weather into fantastic shapes. Tiny human figures emphasize the vast scale of the natural world through which they move. Unlike a Western landscape, the painting is designed to be looked into rather than looked at. There is no single focal point: instead the viewer's eye travels through the scenery, discovering a series of vistas like a traveller wandering on foot through the terrain. Traditionally, distance is conveyed, not by the use of perspective drawing but by working vertically up the picture: convention dictates that the higher up, the further away.

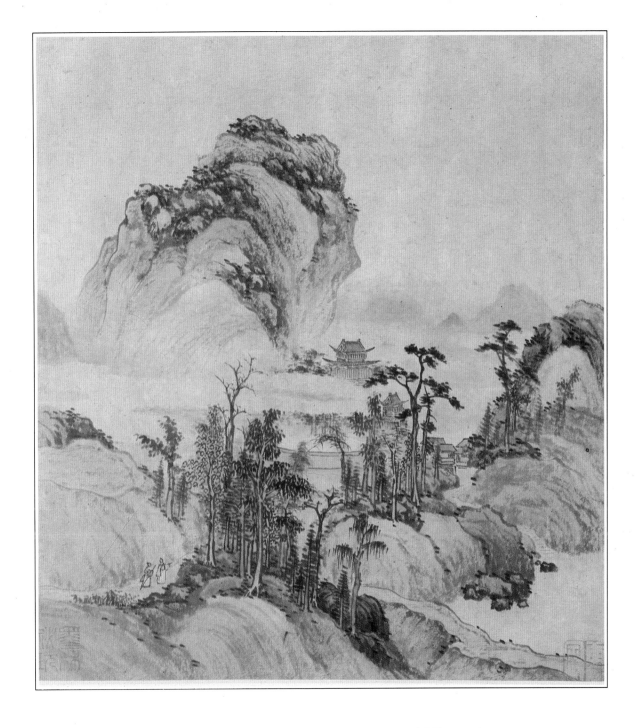

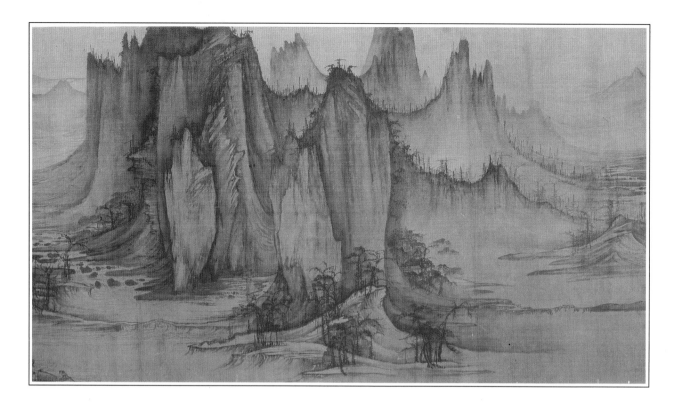

△ **Mountain View**
Ming Dynasty (1368-1644)

HERE WE MOVE FROM WATERCOLOUR to an ink drawing which demonstrates the close relationship in Chinese tradition between the pictorial and calligraphic arts. Both depend on the same principles, and the same brush and water-soluble black ink are here used for both. Working with a stiff, animal-hair brush differing little from that evolved in the late Stone Age, the artist uses the same fine yet bold brushstrokes to form the written characters and the drawing. In this vertical hanging scroll, text and scene combine to form a single statement of the power of nature. Guided by gentle diagonals, the eye explores the mountainside, discovering half-hidden pavilions, tiny tracks and wind-sculpted trees. Hanging scrolls like this evolved from wall paintings, and were not mere ornaments in the home but a reminder for both eye and mind of man's relationship with the natural world.

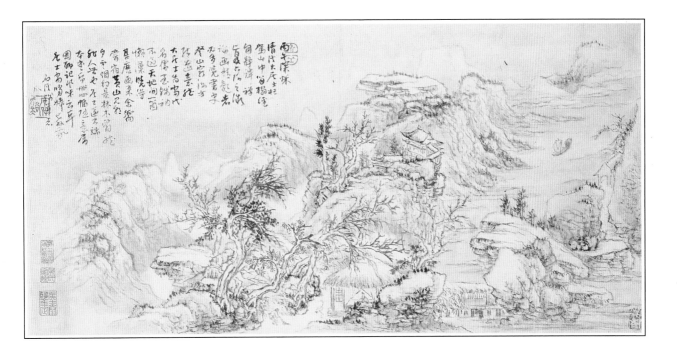

△ **Fishing in a Mountain Stream** (detail)
Hsu Tao-Ning (c970-1051)

LANDSCAPE PAINTING came to its full glory in China in the 10th-13th centuries, under the Five Dynasties (907-960) and the Sung Dynasty (960-1279). This scene is part of a long horizontal scroll, painted in ink on silk, and designed to allow viewers to 'read' their way along as one reads a poem. The scroll was never fully unrolled to reveal the landscape in its entirety, but opened in stages, disclosing some 60 cm (2 ft) at a time. The whole scroll measures some 200 cm (82 in) in length, and originally may have been twice as long. Hsu Tao-Ning was a painter of great originality – perhaps because of his unusual background: at a time when most painters came from the same official class, he started out as an apothecary. He shared his contemporaries' love of bleak, craggy mountain scenes, but brought an individual view to bear, caring, according to a near-contemporary, 'only for simplicity and swiftness of drawing'. His abrupt peaks and misty valleys are drawn with bold brushstrokes and sweeping washes of wet ink.

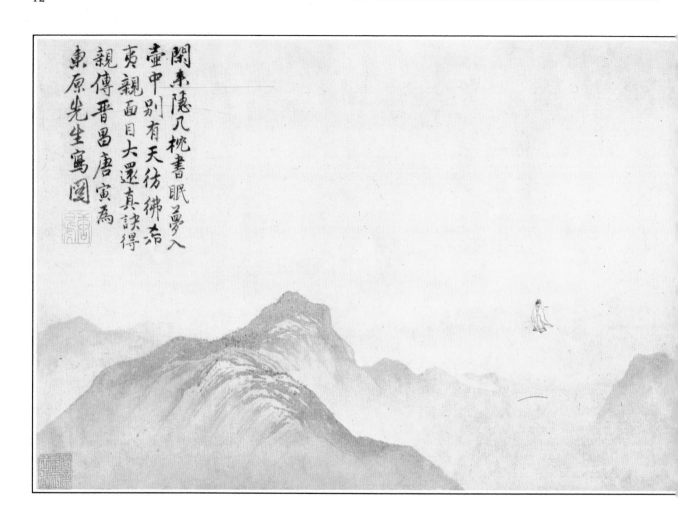

閑來隱几枕書眠夢入
壺中別有天彷彿是
頁親面目大還真訣得
親傳晉昌唐寅爲
東原先生寫圖

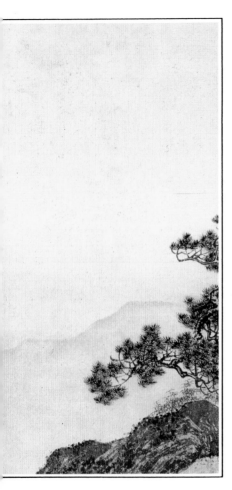

Dreaming of Immortality in a Thatched Cottage
T'ang Yin (1470-1524)

IN A REMOTE COTTAGE among the mountains, the scholar is led beyond the visual beauty of nature to its essence. The viewer's eye is led with him through a richly detailed wilderness, and beyond it to the infinity of space above the dim mountains where the dreaming figure stands perfectly poised in the void. The creator of this tranquil scene led a far from tranquil life. Early in life T'ang Yin wrecked his chances of becoming a respected scholar-painter when he was involved in an examination scandal, and had his degree withdrawn. A talented artist, calligrapher and poet, he became a professional painter, but alternated bursts of dedicated application to his work with equally dedicated application to the wine-shop. In consequence, his paintings are sadly few in number. His romantic landscapes, with their tumbling rock formations and twisted trees, their abundant detail and elegant drawing, owe much to his Sung Dynasty predecessors.

◁ *and overleaf pages 14-15*

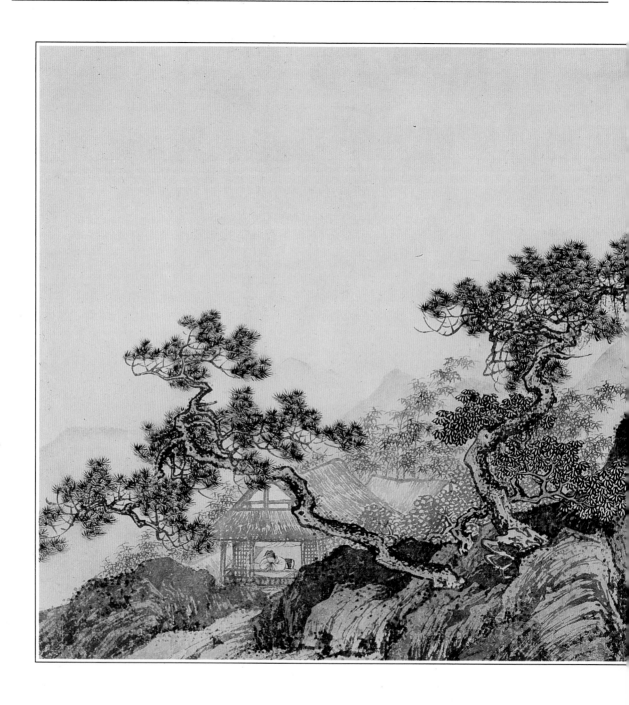

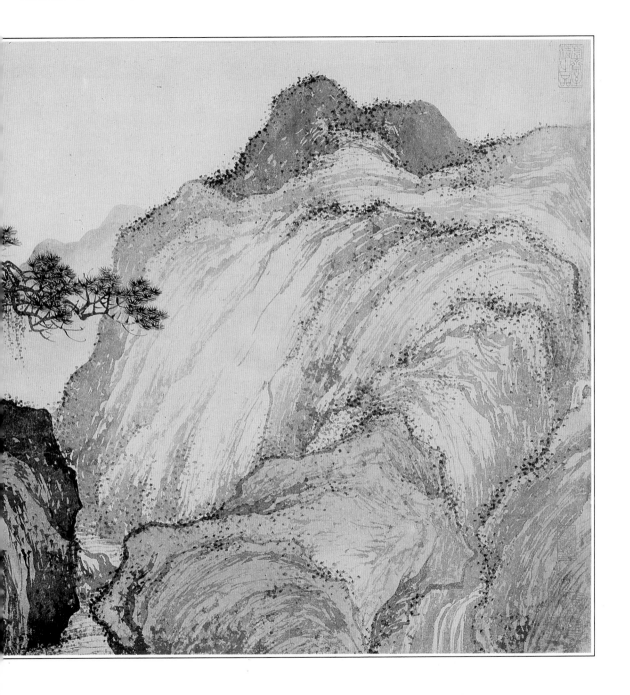

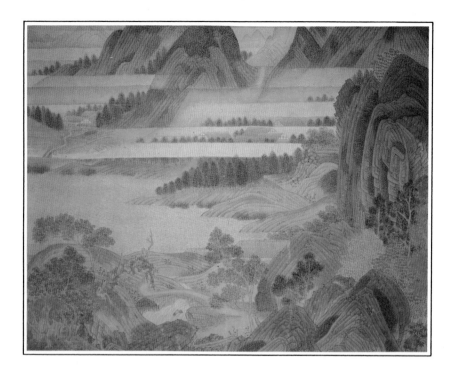

△ **Saying Farewell at Hsun-Yang** (detail)
Ch'iu Ying (1494-1552)

A FANTASY LANDSCAPE in glowing, almost luminous colours. This strongly decorative, highly detailed and brilliantly coloured style of painting, known as the 'blue and green style' from the dominance of those colours, developed in the 8th century. Ch'iu Ying (also known as Ch'iu Shih-chou) was the last master painter to employ it. Like his contemporary T'ang Yin, though for different reasons, he did not conform to the orthodox scholar-painter pattern. He was a professional painter, trained as a decorator. Despite his lack of scholarly background and poetic or calligraphic skills, his elegant brushwork and brilliant use of colour won him recognition among his more educated contemporaries. Indeed, his use of narrative and descriptive themes in paintings did much to open out the narrow range of subjects laid down by scholarly convention.

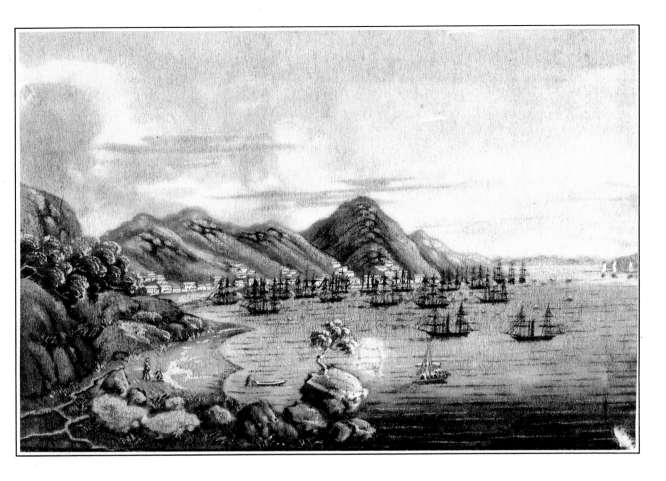

△ **Hong Kong Harbour** (c1850)

MOVING AWAY FROM THE GREAT MASTERS, this is a frankly commercial and distinctly westernized product of more recent times. The scene comes from a book of five views in and around the Pearl River estuary, painted for the export market and designed to appeal to Western taste. Following the First Anglo-Chinese War (1839-42), Hong Kong island itself, with its vast natural harbour, was now a British possession, and we see the British fleet lying at anchor in the harbour. In a more subtle takeover, the artist has adopted some Western conventions of painting, including the use of perspective drawing. This is a plain portrayal of the scene, reporting faithfully to the viewer what is to be seen. We are not meant to look beneath the surface to find spiritual truths. It bears more relation to today's picture postcards, bought as a memento of a holiday, than to the spiritual interpretation of landscapes of native tradition.

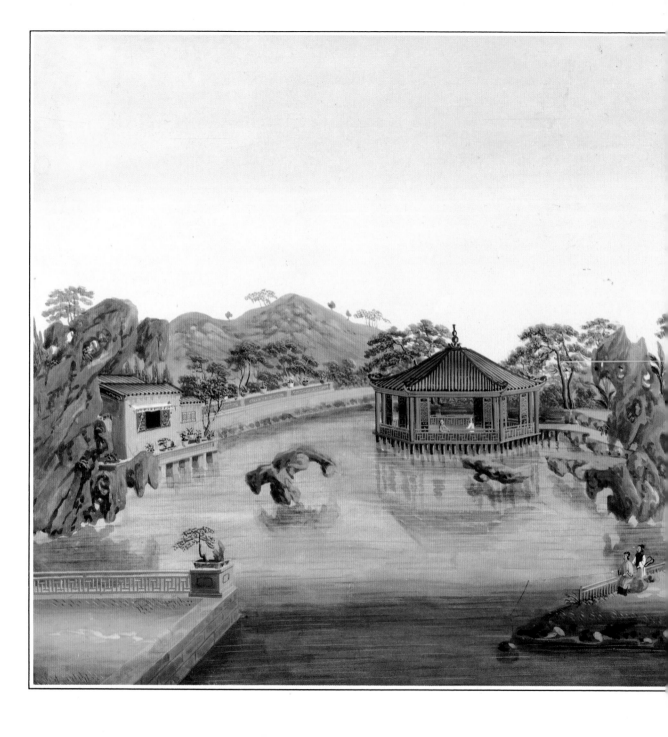

◁ **Garden Scene** (c1820-40)

ANOTHER EXPORT PAINTING depicts a subject dear to the heart of the Chinese. The Chinese garden is as much a work of art as any painting and, like landscape paintings, is designed to create an atmosphere of tranquillity leading the eye and mind towards harmony with nature. In the West, we distinguish between the formal and the 'wild' garden. The Chinese gardener seeks neither extreme, but cultivates in miniature the elements of a natural landscape. The principles have much in common with landscape painting. Like a painting, the Chinese garden offers not a single focal point but a series of experiences, inviting the visitor to ramble from viewpoint to viewpoint. Flowering plants are less important than carefully chosen rocks (representing mountains), trees, water and the essential pavilion for viewing. The 18th century poet Yuan Mei was said to have included no less than 24 pavilions in his garden, each offering a different vista.

Detail

▷ **Peking Imperial Garden** (1800s)

THE IMPERIAL GARDENS were the delight of successive emperors. Emperor Ch'ien-lung (1736-95) alone created hundreds of gardens, including the largest and most perfect of all Chinese gardens, at the Summer Palace, 10 miles from Peking. The Imperial Palace at Peking was a vast, labyrinthine citadel housing some 6,000 people, and its gardens were on a matching scale. The high wall around it reminds us that the palace was known as the Forbidden City – created and maintained for the pleasure of the Emperor alone. He was the only whole man among the 6,000 souls within: all the others were women and eunuchs, and male visitors, even the highest-ranking, were permitted no further than the audience chamber. The gardens were the emperor's retreat from this artificial and isolated world. Ch'ien-lung not only spent a fortune constructing his gardens, but took pride in choosing appropriate names, including the Realm of Fragrance, the Happy Place of Falling Streams, and the Garden of Clear Rippling Waters.

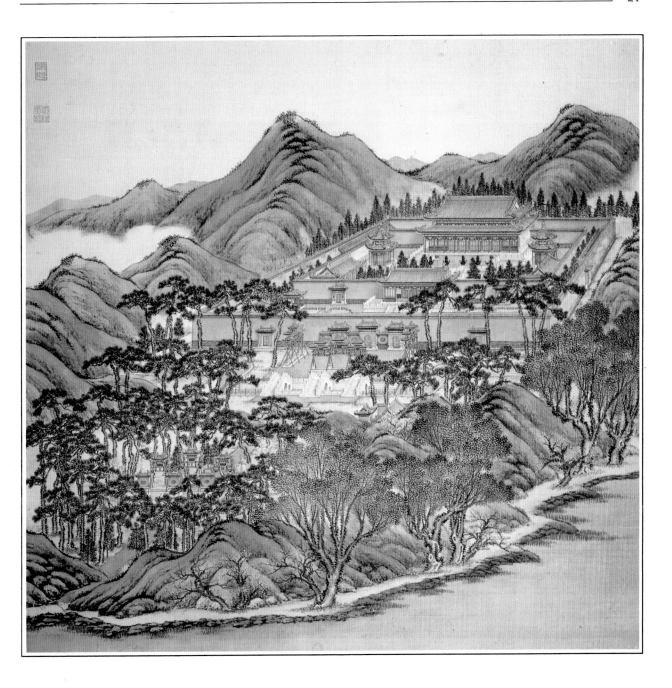

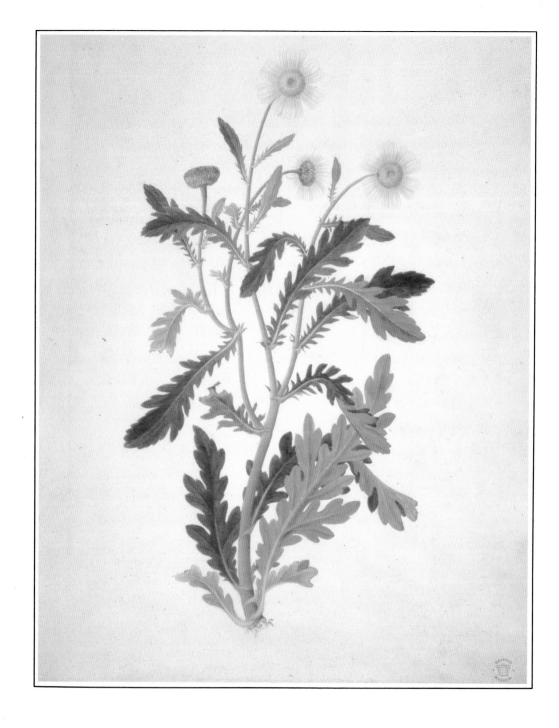

◁ **Crown Daisy**

EXPORT PAINTINGS OF FLOWERS
often remained truer to native
Chinese tradition than those of
landscapes, aided by the fact that
naturalistic flower-painting had
been practised for centuries.
Chinese brush painters employed
two ancient techniques: the near-
impressionist 'boneless' style, and
the contour or outline style used
here, which achieves a meticulous
likeness. The contour style
produced finely detailed flower
portraits of great botanical
accuracy. When China opened up
to the West, European naturalists
no less than art collectors were
eager for illustrations of its exotic
plants – and delighted to find
Chinese artists with the skills to
produce precise portraits of
flower specimens. Many were
specially commissioned. Here we
have a finely detailed study of a
crown daisy. Stems and leaves are
given the same attention as the
brilliantly coloured flowers – as,
in true Chinese tradition, are the
rusty blemishes on the tips of
some leaves.

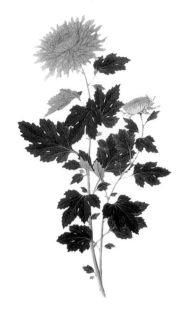

△ **Chrysanthemum**

The precision of this painting is
that of a botanical study; but its
subject is something more. The
chrysanthemum is notable as one
of China's Four Noble Plants.
Symbolism is central to the
meaning of Chinese art. A flower
is not merely a flower, but a
symbol of something more. For
example, the Mowtan peony, 'king
of flowers', symbolizes spring, the
camellia, prosperity and the
magnolia purity. Above all,
Chinese tradition honours the
Four Noble Plants, or Four
Paragons: plum blossom, orchid,
bamboo and chrysanthemum.
Each represents a virtue. The

plum blossom symbolizes
venerable old age and fortitude;
the orchid, piety and virtue; the
bamboo, faithful performance of
duty. The chrysanthemum, which
blooms alone in autumn as other
flowers wither, is a symbol of the
unworldly scholar and recluse,
who devotes his life to the pursuit
of excellence in poetry,
calligraphy, painting and music.
Together, these four plants
symbolize the highest Chinese
virtues, uniting in the revered
figure of the scholar.

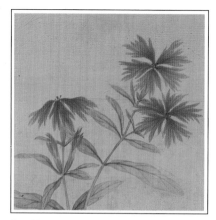

Detail

▷ **Flowers**

THE CAREFULLY DELINEATED leaves and stems of these blooms demonstrate the technique of contour-style painting. The artist begins by drawing his subject – including the veins of the leaves – in outline with fine, accurate brushstrokes. Then ink or colour washes are added, after the outlines have dried. This method produces a realistic likeness. Traditional Chinese flower studies often concentrate on a single species, but here we have an arrangement where the anonymous artist has chosen blooms which give a satisfying contrast of shape and colour. As well as a fair degree of botanical accuracy, the picture has a delicate charm, particularly in the relationship of the fine leaves, interlacing with each other. Nothing about it is alien to Western conventions of flower painting – but note the one ragged and browning leaf, which a Western artist might have tidied up, but which is painted with the same meticulous care as the flowers themselves.

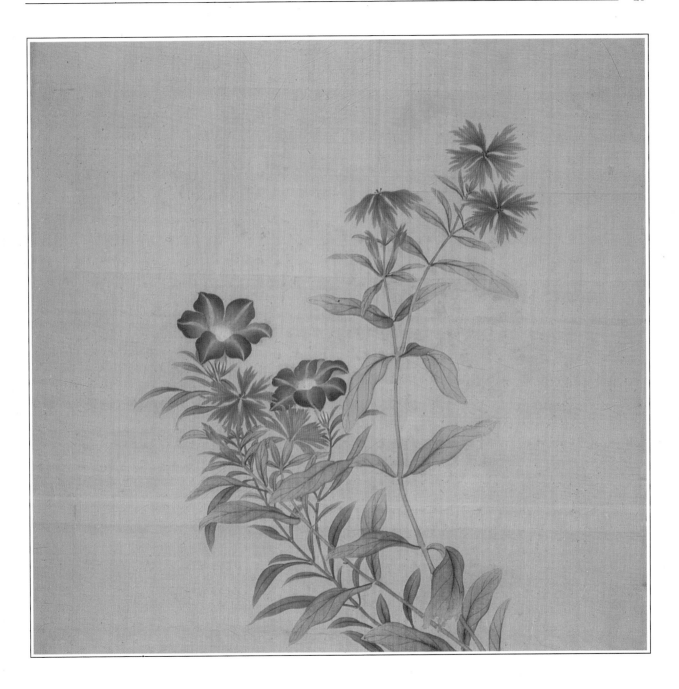

Detail

▷ **Ornamental Basket of Flowers** (1800s)

THIS STRONGLY WESTERNIZED ARRANGEMENT of flowers reflects the insatiable demand for chinoiserie in 19th-century Europe. It is a clear example of the 'paintings for foreigners', a painting made to satisfy non-Chinese expectations and aesthetic criteria. Here we have gaudy, exotic blooms, conventionally rather than accurately painted, set in an exotic vase to please the tourist trade. Considered by Western buyers as typical Chinese art, such work owes as much to native Chinese tradition as most popular modern holiday souvenirs owe to the countries where they are sold. But, in the early 19th century, most Westerners condemned China's indigenous traditions of painting as 'miserable daubs', and were quick to praise the westernized products of Canton painting workshops which had 'acquired a better taste than in the interior parts of the country'.

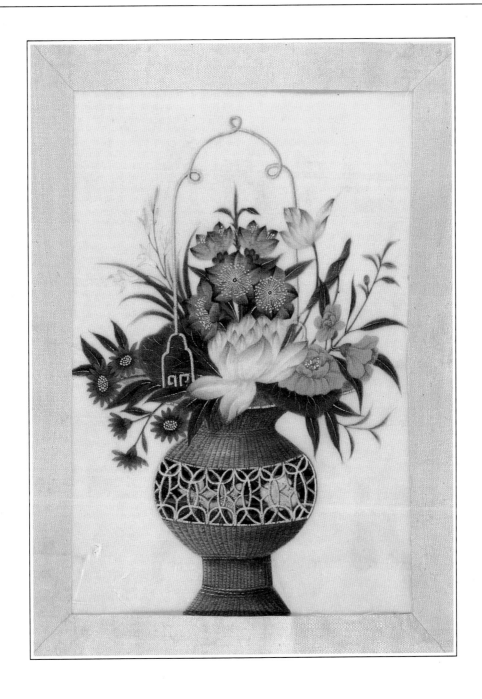

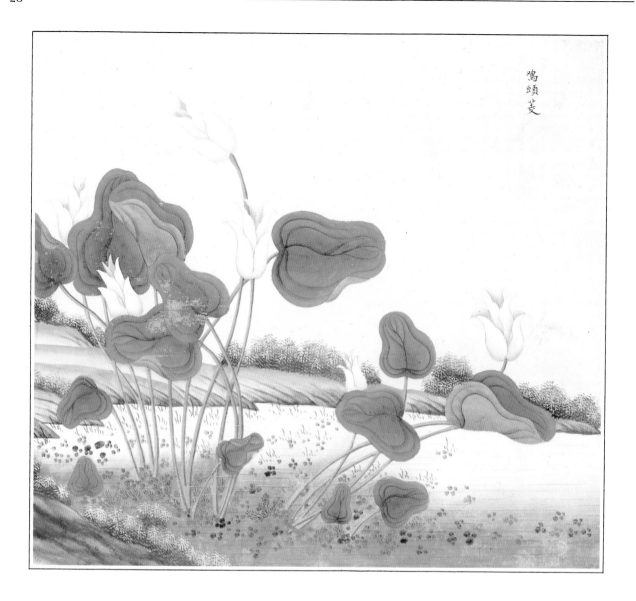

鶏頭菱

Detail

◁ **Flowers** (1700s)

THESE WHITE WATER-LILIES have clearly been 'recollected in tranquillity' in the studio, rather than painted meticulously from life. The unknown artist has chosen to stylize his subject into a delicate pattern. The luxurious green leaves dominate the picture with their formal, regular curves and strong colour. The flowers themselves are almost understated, drawn in outline with only the subtlest hint of shading, then crowned with brilliant crocus-yellow. The setting is conventional rather than realistic. Gradual lightening of colour leads the eye across the lake, from its green-washed foreground to the clear waters further from shore and the far banks, depicted quite simply with regular brush strokes. The white-tufted plants that appear in foreground, middle and on the horizon are identical in appearance and scale, yet pass quite satisfactorily both for low-lying groundcover on the near shore, and full-sized trees further away.

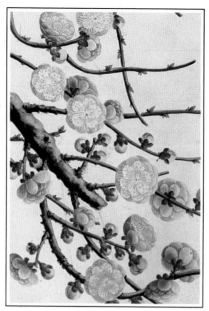

Detail

▷ **Peach blossom** (1800s)

SPRING BLOSSOM CARRIES A MESSAGE of rebirth, emphasized by the contrast between the gnarled and battered branch and the fragile flowers it bears. Peach blossom itself symbolizes immortality, springtime and marriage: the peach is known as the 'Fairy Fruit' of China . Out of this dead-looking wood springs new life. The branch is painted boldly to bring out its rough texture and weathering. The smoother lines of the young green shoots flow out from it in expressive, interlaced curves. The blossom is traditionally painted last, and is depicted in a much more delicate style. Where the painter has revelled in every knot and gnarl of the weathered branch, he has chosen to portray every fragile flower as perfect, not a petal out of place. The painting's realism is more apparent than actual: each flower has been created as a formal, regular and stylized pattern rather than copied from life.

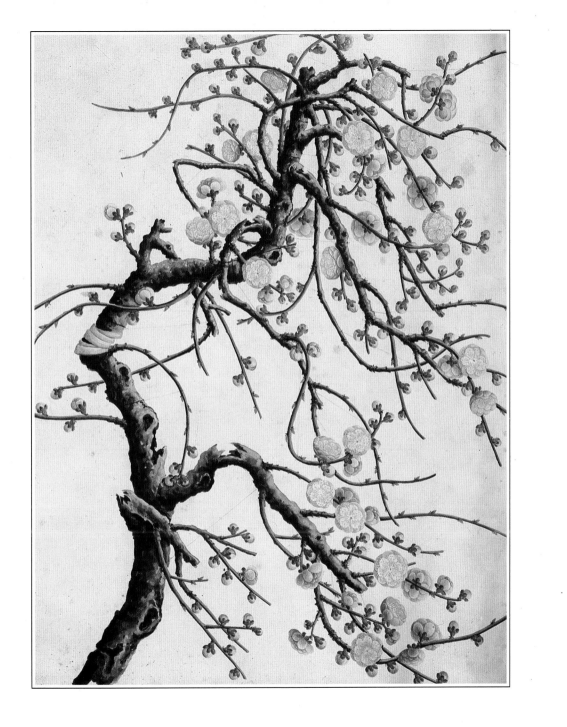

▷ **Lotus Flower**
Yun Shou-P'ing (1633-90)

YUN SHOU-P'ING BELONGED to the Orthodox School of the early Ch'ing period, members of whom based the content and style of their paintings on lines laid down in the Sung Dynasty (960-1279). He was described in his time as the greatest painter of birds and flowers, and is particularly noted for his mastery of the 'boneless' style of painting. Where contour style depends on line, the 'boneless' style is worked entirely in colour wash without use of outlining. Swift, free-flowing brushstrokes are completed before they dry so that they blend together. The aim is not a naturalistic study, but a vivid impression of the essence of the subject. It is particularly effective in flower studies like this lotus bloom. This study is typical of Yun Shou-P'ing's keen observation and his delight in the natural twists and turns of leaves. The sweeping, confident arcs of the long slender grass-blades behind add to the impact of the lotus's massive leaves and vivid bloom.

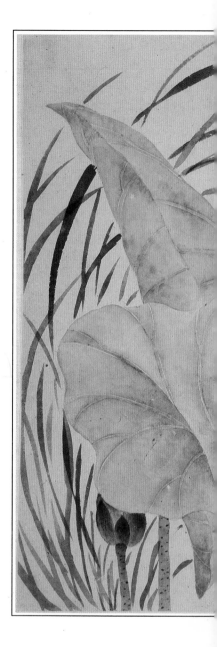

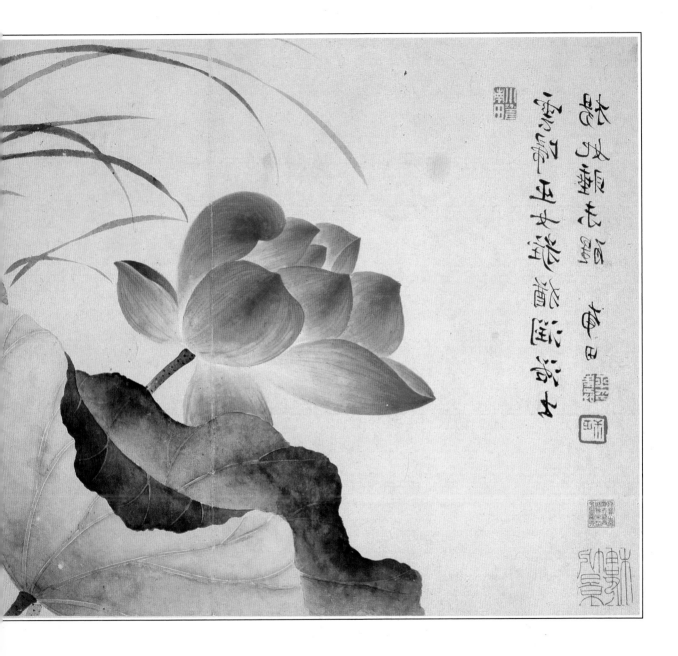

Detail

▷ **Lotus: design for a trademark** (1891)

THE LOTUS IS REGARDED in China as the 'superior man' among flowers. It is certainly one of the most striking of plants. Its huge round leaves are among the biggest borne by any flowering plant, its towering stems rise a man's height above the water, and its flowers, in pink, white or yellow, are both large and dramatic. Its beautiful, fragrant bloom growing out of the mud is a symbol of purity and, in Buddhist tradition, of the soul arising from the darkness of materialism into enlightenment. It also symbolizes summer, with the related images of happiness and purity. The lotus appears repeatedly in paintings, embroideries, carpets and ceramic decoration, for its decorative flowers, leaves and large, flat-headed seed pods make a fascinating subject. This formal, conventionalized design from a Shanghai workshop combines watercolour and woodblock on paper.

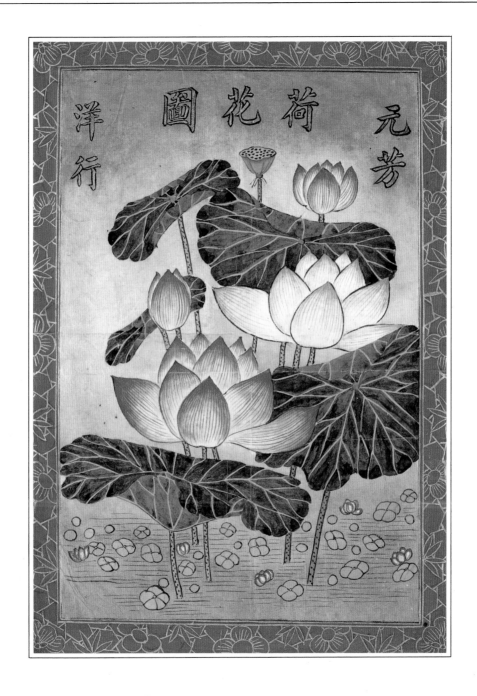

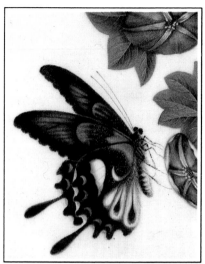

Detail

▷ **Flowers and Butterfly** (c1860)

INSECTS ARE OFTEN INCLUDED in flower paintings, as an ornamental extra and also, often, to balance the composition as a whole. Bees, flies and dragonflies are common, but the butterfly is perhaps the favourite choice. It is not only a decorative complement to any flower painting, but also a symbol of summer, joy, and married happiness. This painting, produced for export at a Canton workshop, depicts a swallowtail butterfly visiting the blue flowers of morning glory. It is at once accurate in its observation and yet delicately stylized in its interpretation. The rounded flowers and the exultant upswing of the spurs on the insect's wings are more decorative than realistic. The swallowtail is poised improbably on the incurved edge of two petals, adding a formal element of artificiality to the arrangement. But it is a delightful grouping, and shows up the versatility of the Chinese brush: compare the boldness of shading on the petals with the marvellous precision of the tiny hairs on the insect's legs.

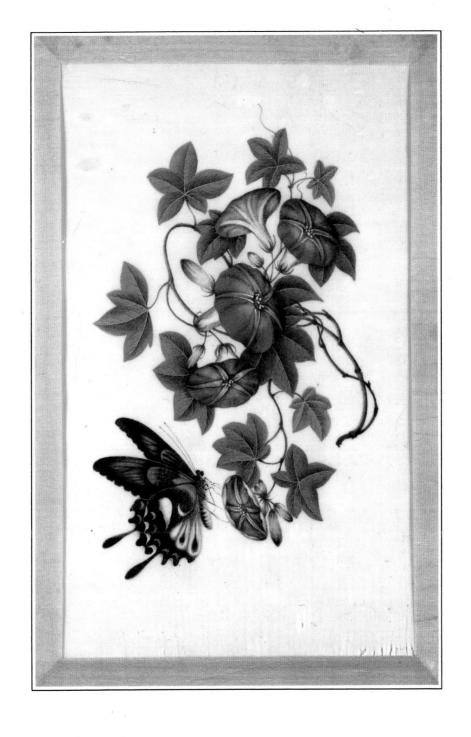

Detail

▷ **Butterfly with Marigolds**

THE SAME SUBJECT AS ON page 36, but how different the effect! Here we have a much more delicate and understated interpretation of the theme of butterfly and flowers. Once again it is the highly decorative swallowtail butterfly, this time heading for a group of marigolds, and joined by two little bees at the top of the picture. The butterfly is no mere ornamental addition but an integral part of the composition, forming with the marigolds a paired relationship known as the Host-Guest principle (*pin chu*). Here the flowers form the passive element, the Host, and the butterfly the active element, the Guest. The balance between them as they turn towards each other holds the picture together. A secondary relationship is formed between the bees and the upper flowers, completing the balance overall.

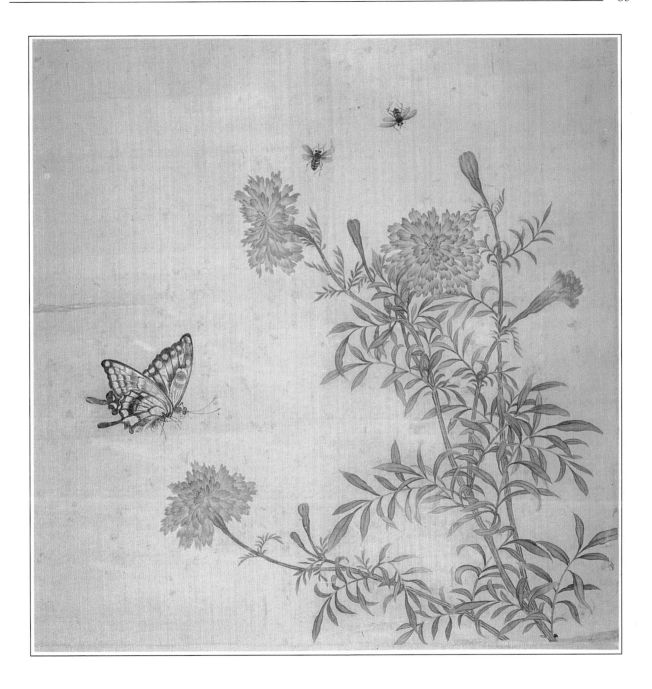

Detail

▷ **Butterflies and Flowers**

MORE THAN JUST A PORTRAIT of butterflies and flowers, this painting carries a message about permanence and impermanence, the strength of nature and the nature of strength. The fragility of pink vetch flowers, golden lily and two butterflies is set against a standing rock. Stones like this, powerfully sculpted into curves and hollows by the forces of nature, often feature in Chinese paintings – and as one of the most important elements in Chinese gardens, often brought from far afield at great expense. Never mere ornaments, as they might be in a Western garden, they inspire contemplation. In this painting, the juxtaposition of butterflies and flowers with such a rock can be read in several ways. Insects and blossoms are frail and ephemeral: rock is strong, enduring. Yet, though short-lived as individuals, butterflies and flowers carry the promise of rebirth and the immortality of the species; the rock, solid though it seems, has been eroded by time and weather and its destiny is dust.

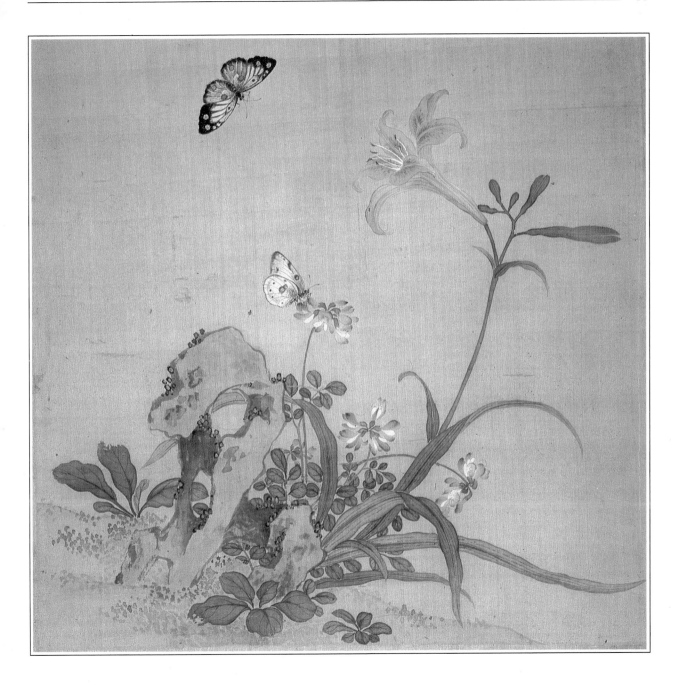

Detail

▷ **Wild Roses with Grasshopper**

FRAGILE BLOOMS AND INSECT are juxtaposed with a craggy rock. While insects, rocks and flowers are favourite themes, the wild rose is a rare subject in Chinese art, perhaps because of the tradition that it is unlucky. According to folk belief, wild roses blooming in the garden will lead to dissension in the family. Yet its spiky stems, jagged leaves and tender blooms lend themselves well to this painting style. Traditionally, the flowers are painted first, then the leaves, and last of all the branches.

The rock is drawn in outline, then further brushstrokes added to make it three-dimensional; next shading is added, and finally the grey colourwash. The placing of rock and roses, and the angle of the spiky stems, focus attention on the grasshopper – the one transient element in the picture. The swift, jerky strokes with which the insect's body and legs are touched in add to our awareness that the artist has captured the fleeting moment before rock and roses are left alone again.

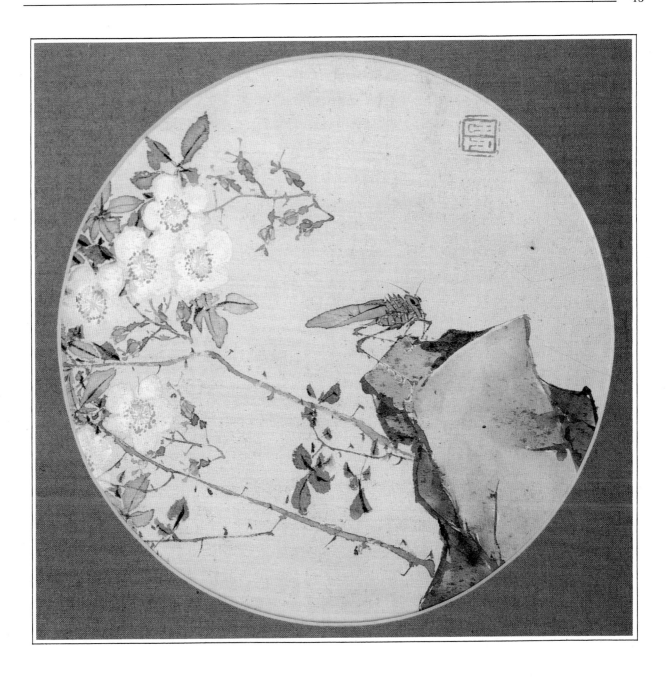

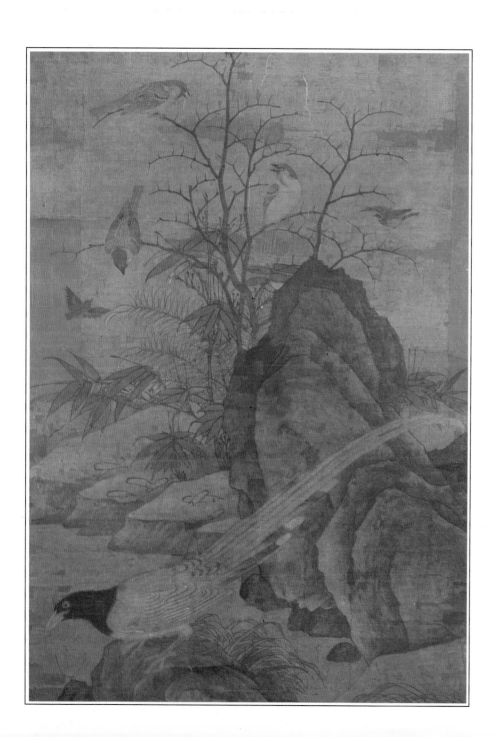

◁ Silver Pheasant and Sparrows
Huang Chuts'ai (900s)

BIRD-AND-FLOWER PAINTING came to equal landscape painting in importance during the Tang Dynasty (618–907), achieving its full glory in the Sung Dynasty (960-1279). This was a period of cultural expansion, the age of scholar-painters and poets, sponsored by emperors who not only encouraged and collected art, but were often themselves fine painters. Huang Chuts'ai worked as Painter-in-Attendance to the Emperor T'ai-tsung (976–97) and as curator of the imperial collection of painting and calligraphy. Like his father, Huang C h'uan (also a court painter), he was famed for his paintings of birds, flowers and rocks from the imperial aviaries. The fine brushwork and attention to detail are characteristic of palace art of this period. A century after Huang Chuts'ai's death the imperial collection included 332 of his paintings, though sadly few survive today. The silver pheasant shown in his painting is a native Chinese species, long valued in aviaries for its elegant black-laced white plumage.

▷ Dog in the Bamboo Grove
Emperor Hsuan-te (1426–35)

EMPEROR HSUAN-TE was no mere patron of the arts, but himself a painter of real ability. He specialized in lively, sensitive studies of animals, often among the plants and rocks of his beloved gardens. This study of one of the imperial dogs seated among the imperial bamboo is rich in symbolism. The bamboo, a favourite subject of Chinese artists and poets, is one of the Four Paragon plants, symbolizing faithful performance of duty. Often called the 'friend of China', it is also a symbol of courage in adversity, for it bends to the wind but never breaks, and of benevolence, for it offers shade to the traveller. The Pekingese dog is not only a palace dog, emblem of imperial power, but also the symbol of Buddha. In Chinese tradition, the little lion-dog represents the spirit lion upon which Buddha rides and which, when he chooses, shrinks to lapdog size to ride in the sleeve of his robe.

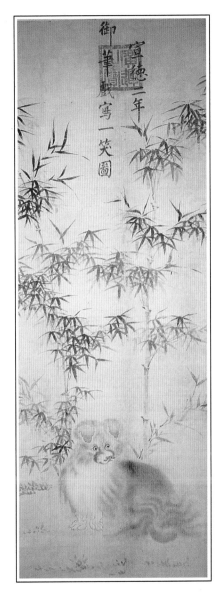

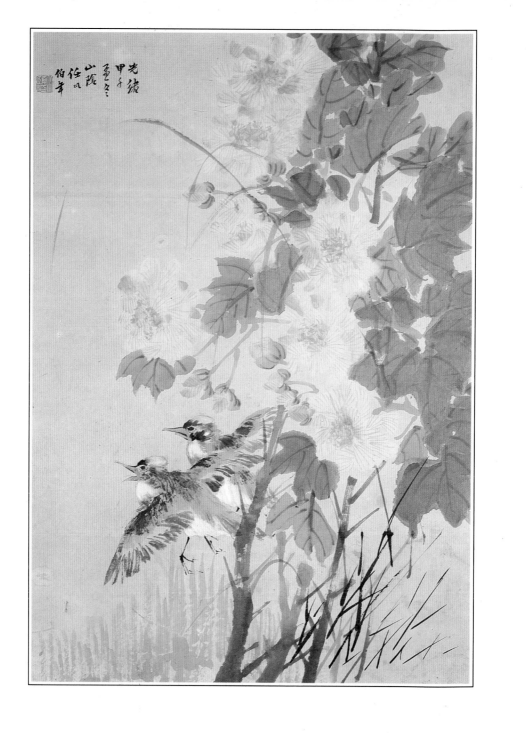

◁ **Hibiscus and Flying Kingfishers**
Jen Po-nien (1840–1895)

ONE OF THE LEADING PAINTERS of the late 19th century, Jen Po-nien specialized in bird-and-flower pictures in traditional Ming style. Born in Chekiang, he worked in Shanghai where he became one of the most significant members of the White Lotus Society of painters. His work is characterized by a distinctive energy, swift, almost jerky brushstrokes, and bold use of colour. This small painting, in ink and colour on paper, is dated 1894. Making brilliant use of the 'boneless' style, without outline, he creates an effect of movement and immediacy. This is a free, spontaneous technique, ideally suited to capturing the fleeting moment as the two blue-crowned kingfishers take flight. Using the fewest possible strokes, the overlapping leaves and stems are painted in a free, bold style , with short sharp strokes creating the hibiscus blooms. The same speed of painting catches the immediacy of the birds' flight, so that the whole picture is full of energetic life.

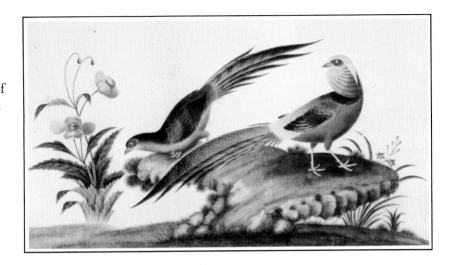

△ **Golden Pheasants**

IN CONTRAST TO THE PICTURE ON page 44, here we have a purely static bird portrait. The ornamental pheasant, symbolizing beauty and good fortune, continued to be a popular subject in art and embroidery long after the time of Huang Chuts'ai. The golden pheasant, one of the most striking members of this group, is native to central and northwest China and has been a treasured aviary bird for centuries. This study of a cock and hen bird is a late work, probably painted for export. The cock's exotic plumage is touched in impressionistically, rather than with the feather-by-feather detail in Huang Chuts'ai's painting. The end result, though attractive, is rather stilted and artificial – especially since, even in real life, the dramatic plumage of the golden pheasant looks far too decorative to be true! The grouping of the two birds and the rock forms a satisfying arrangement, but no attempt has been made to integrate the poppy with the rest of the scene: it is merely a decorative addition.

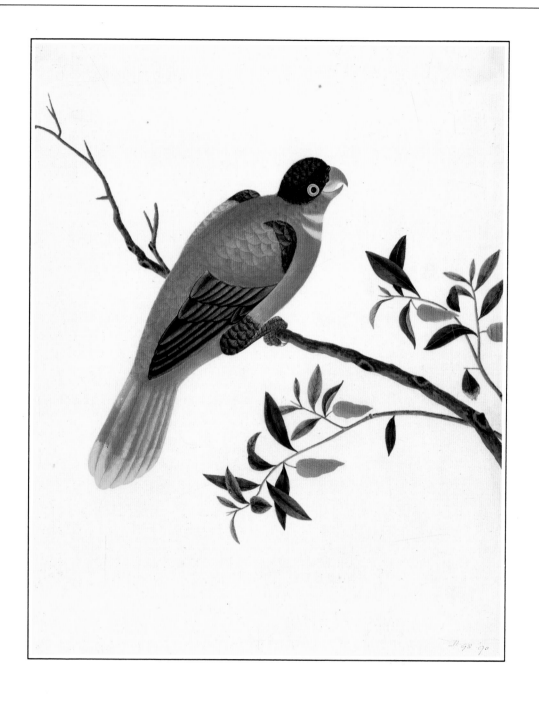

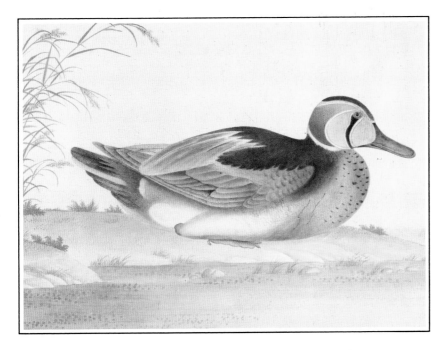

◁ **Shoveller Duck** (c1800-1820)

THE DUCK IS A SYMBOL OF HAPPINESS in Chinese tradition, and was often painted as such, but here we have a study in natural history rather than a pictorial message. This closely observed portrait of a duck, with its attention to detail and much more naturalistic style, is almost certainly an earlier work. Here aesthetic quality and scientific accuracy are happily combined. Particular attention has been paid to shape and colouring, from the delicate stippling on the breast to the brilliant speculum on the wing. It is a static painting, with the duck at rest on land, its webbed feet tucked under the body. This painting is perhaps the most naturalistic, and finest, of a group of 10 bird and flower paintings from different workshops and ranging across different styles.

◁ **Parrot on Branch**

WHEN CHINA WAS OPENED UP TO the West, the long-established tradition of bird-and-flower painting meant that Western zoologists found artists readily available to produce accurate watercolours of unfamiliar, exotic Asian species. Many such paintings were specially commissioned, as may have been the case with this study of a small parrot. By the mid-19th century, the tendency of export workshops producing natural history paintings was, as we see here, away from the scientific accuracy of earlier studies and towards a more decorative treatment. The parrot is drawn in a conventional style, making no concession to the shape and proportions of this particular species – indeed, apart from colouring and beak shape, it could just as easily be a pigeon! Note particularly the stylized treatment of the feathers, forming an identical pattern on crown, back and upper wing.

Detail

▷ Cat and Butterfly

WITH A FEW DECEPTIVELY SIMPLE and economical brush-strokes, in almost cartoon style, the artist shares with us his delight in a brief, comical confrontation, perhaps spotted during a period of contemplation in his garden. The cat, sitting in the sun, has its attention caught by the flickering movement of a butterfly behind the grasses, but is too comfortable, fat and lazy to move more than its eyes. Look at the expression on the beast's face! Those bulging yellow eyes dominate the picture, expressing its feelings and whole personality. Note the arrangement of the two creatures in the painting as a whole. Cat and insect form a pair of 'Opening and Closing' (*k'ai ho*) elements holding the picture together, an extension of the common Host-Guest principle where two elements form a paired relationship representing the passive and aggressive.

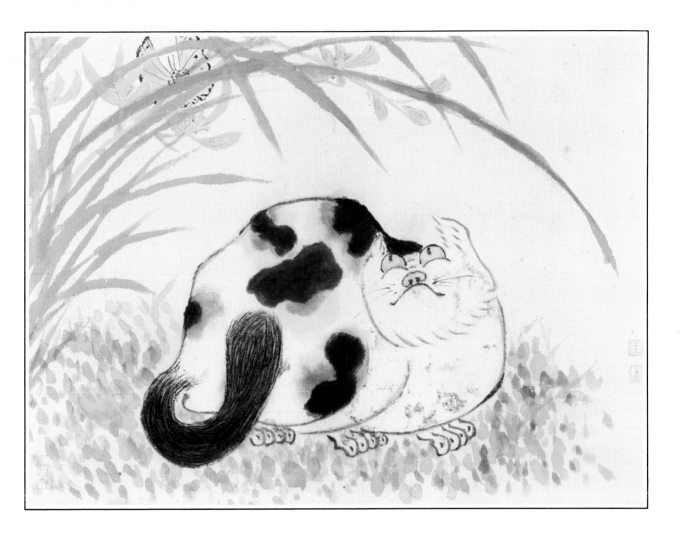

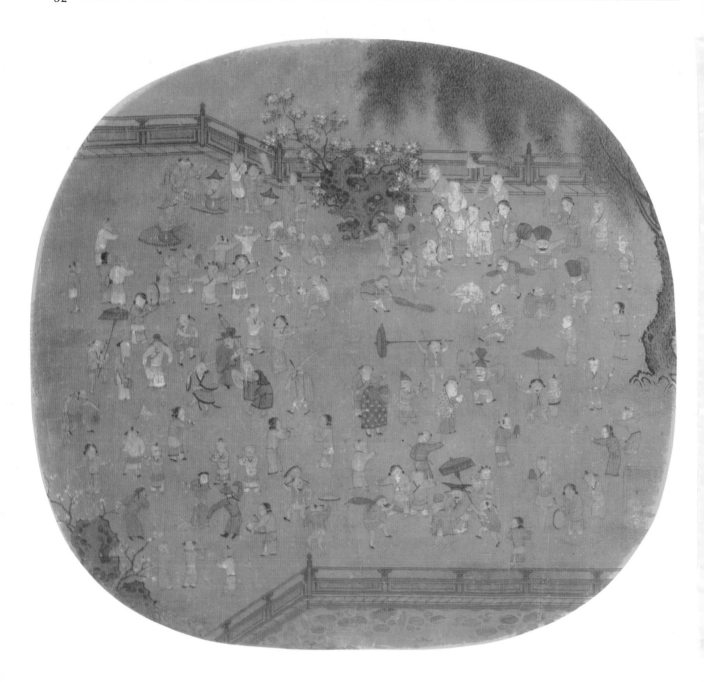

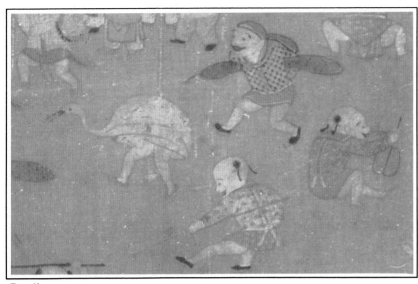

Detail

◁ **A Hundred Children at Play**

PAINTED DURING THE SUNG DYNASTY (960–1276), this glorious medley of children looks odd to the Western eye at first. There is no perspective in the Western sense, and the children, conventionally drawn stumpy little figures, look a bit like little old men, especially the boys with their shaven heads. Yet we quickly recognize the universal and timeless quality of a school playground, with the crowd broken up into little groups enjoying their separate activities. Some are playing musical instruments. One pair of boys is engaged in a game of shuttlecock (*chien-tzu*), another in a bat-and-ball game where the ball is painted to resemble a head. Other children are mounted on elaborate hobby-horses, while one crouches under a duck-shaped shell. This is an affectionate portrayal of childhood, secure in a play area protected by walls and sheltered by the large tree that embraces the edge of the picture.

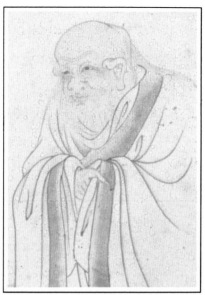

Detail

▷ **Lao-tzu**
Ch'ien Ku (1500s)

THE SUBJECT OF THIS PAINTING, the legendary sage Lao-tzu, is thought to have lived some 2,000 years before the artist. He lives on as the venerated founder of Taoism, which with Buddhism and Confucianism remains one of the main religions in China. Strictly speaking, Taoism is less a religion than a mystical philosophy, emphasizing harmony with nature. Tao, 'the Way', is the unseen reality lying behind appearances. Taoist belief was to have a profound impact on the development of art in China. Its preoccupation with the spiritual presence in the world of nature led to the growth of landscape and bird-and-flower painting. Artistic creativity and meditation became inseparably entwined, hence the Chinese artist's preference for working from his mind's eye rather than from life. Ch'ien Ku has portrayed the sage beneath a symbolic pine tree, which represents the man of principles, fortitude and faithfulness.

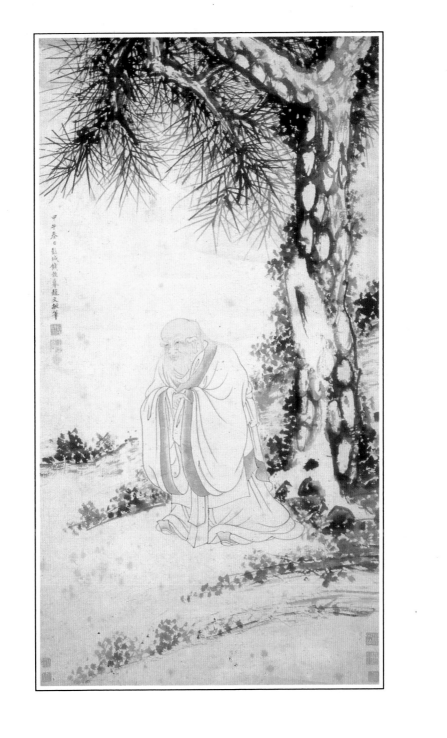

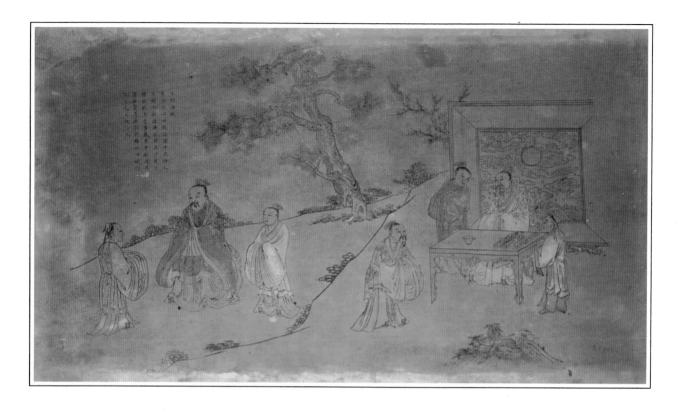

△ Scene from the Life of Confucius and His Disciples (1700s)

Very different in style from page 54 is this early 18th century depiction of another great sage, Confucius, a near-contemporary of Lao-tzu. Where Ch'ien Ku chose to depict a moment of stillness, here we have a narrative picture, fully peopled and full of interest. Once again the enduring pine tree carries its message of upright virtue. The figures and their billowing robes are drawn in traditional style, with fine, flowing lines and conventional pleats and folds. Confucius, or K'ung Fu-tzu (551-479 BC), abandoned a successful government career to become a wandering sage and teacher. He is shown here with the disciples who accompanied him on his travels. After his death, his teachings on moral conduct as the basis of social and political harmony gradually crystallized into the Confucian religion, which was dominant for much of the history of imperial China.

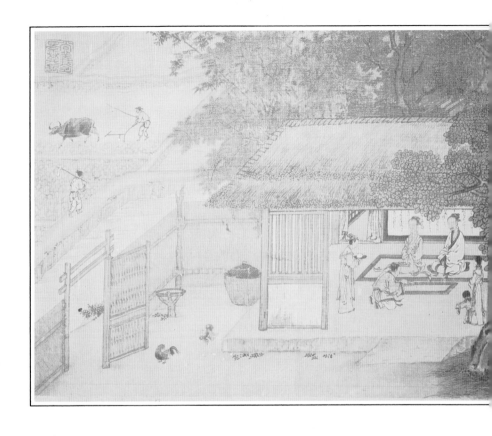

△ **Filial Piety** (1100s)

ACCORDING TO CONFUCIAN TEACHING, the family is the basic unit of society. The individual is bound to observe obedience to the family group; and if all family groups are in a state of harmony, there will be no conflict within the society as a whole. In this 12th century picture, the approved social order is portrayed in an orderly, even severe ink drawing, mainly monochrome with just a few touches of colour. House, yard and rice fields offer uncluttered straight lines. Within the house, honoured parents are served by obedient and respectful children. In the yard outside, the cock is an emblem of faithfulness to duty. And in the fields beyond, labourers and ox toil virtuously at their tasks. The whole scene is a microcosm of the harmonious functioning of society.

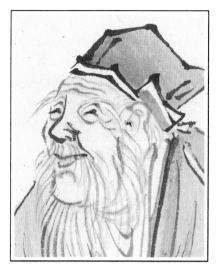

Detail

▷ **Jurojin and Stag** (c1850)

ANOTHER EXAMPLE OF LINE DRAWING, using a fine brush and with sparing use of colour wash. The brushstrokes are confident and sweeping, the shading minimal. Detail is used only for the sage's face, and to a lesser extent to depict the conventionalized knots in his walking stick and the texture of the stag's antlers. It is an understated picture of peace and tranquillity, but not without merriness, for the sage wears a broad if benevolent smile. It may be meditation that has brought him to this happy state, or he may be elevated by rice wine, a state not considered incompatible with philosophy. His companion the stag is an emblem of long life, for it has mysterious powers enabling it to find the sacred *Lung Chih*, the fungus of immortality.

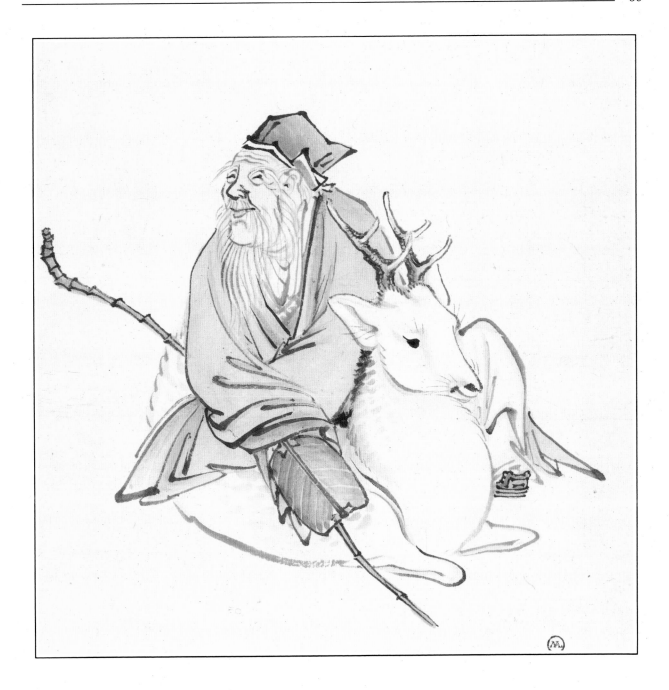

▷ Emperor K'ang Hsi Inspecting the Building of a Dyke

A SCROLL PAINTING OF THE
CH'ING DYNASTY (1644–1912)
depicts a horde of busy labourers
toiling away for the benefit of the
Emperor. Some dig, some tie up
bundles of reeds, some drive in
posts and some lug poles or carry
buckets of water. It is a picture of
industrious activity reminiscent of
an anthill. The vast, foaming
billows of the river against which
the little figures labour to build
their dyke demonstrate their
puniness against the forces of
nature. Yet their sheer numbers
remind us that even ants, working
together, can change their
landscape. K'ang Hsi (1662–1722)
was an enlightened patron of the
arts, who set up workshops for the
decorative arts and gathered
around him a court of painters,
calligraphers and poets. But this
picture celebrates his humbler
servants, whose physical labour is
essential to support the luxuries of
higher culture.

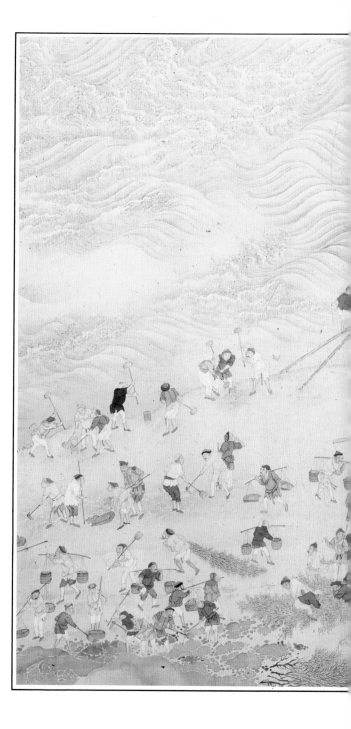

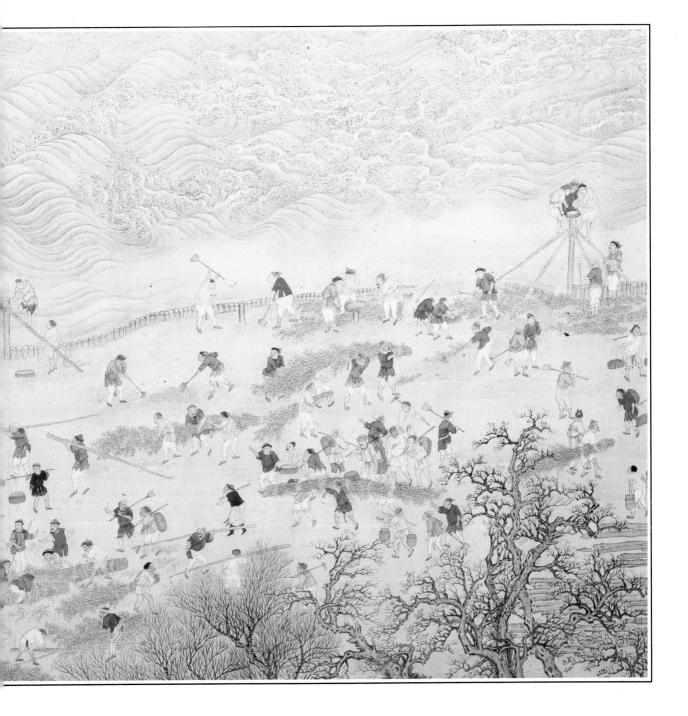

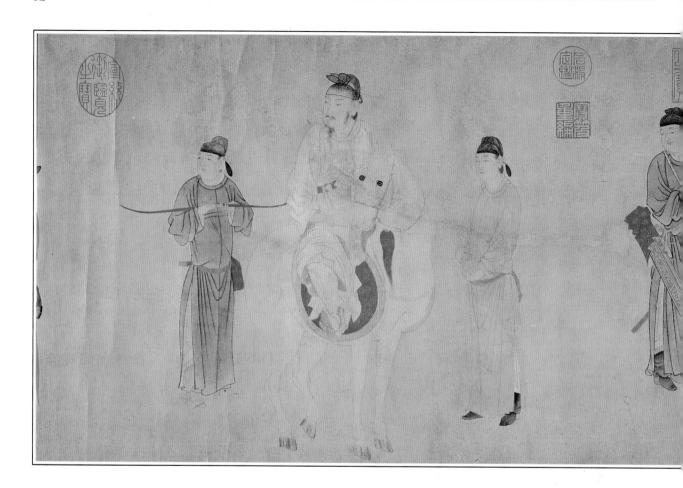

◁ Emperor Hsuan-tsung Watching His Favourite Mount a Horse

A T'ANG DYNASTY SCROLL depicts the Emperor Hsuan-tsung (685–756), known as Ming-huang, 'the Brilliant Emperor', with members of his court. Hsuan-tsung's reign (712–56) was a high point in Chinese culture. A powerful figure who seized the throne in a period of corruption, he took steps both to reform the state's government and improve its finances and defences, and had energy to spare to patronize the arts, poetry and music. At this period wall-paintings were the most important medium of art, but handscrolls were also painted. Here, fine ink drawing is combined with a rich use of colour wash. The artist delights in the fluent curves of the animal's body, although the head with its oddly placed eyes and ears seems to have defeated him somewhat. Hsuan-tsung prized his horses greatly, importing fine stock from far lands. His stables housed more than 40,000 animals, of the 'Flying Yellow', 'Night-lightning', 'Drifting Cloud' and 'Five Blossom' breeds, which inspired great horse painters Han Kan and Ch'en Hung.

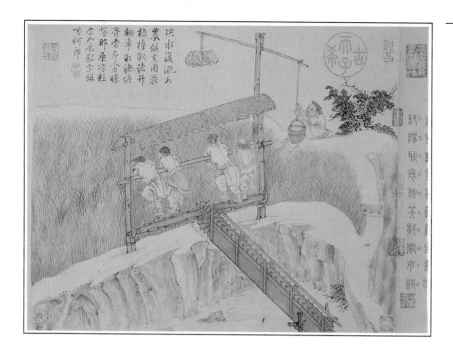

△ Cheng Chi Rice Culture: Irrigation

RICE CULTURE HAS BEEN AN IMPORTANT ELEMENT in Chinese life since 5000 BC, shaping the country's landscape with its acres of paddy fields as well as supplying a major part of the people's diet. The Chinese practised intensive cereal cultivation long before farmers in the West. Here we have one of a set of paintings depicting the stages of rice cultivation, painted in the Yuan Dynasty (1276-1368) and attributed to the painter Cheng Chi. The complexities of the man-powered irrigation pump are drawn in careful detail, while the scenery of rocks, river and young rice plants are sketched in with softer brushstrokes. The human figures draw our eye: we are left in no doubt that this is hard, gruelling labour which goes on for hours. It is noteworthy that these figures are no mere conventionalized drawings. The artist has taken care to individualize them, with differences in costume, hairstyle and faces, so that we feel these are members of a real community going about their daily work.

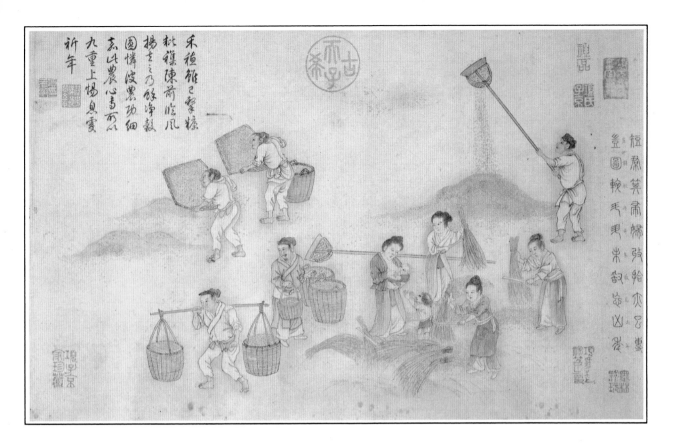

△ Cheng Chi Rice Culture: Threshing

ANOTHER PAINTING FROM THE SAME SERIES shows a later stage in the culture of rice. All that labour has paid off now that it has come to harvest time, and the workers are busy threshing the grain that will feed their community. Once again, the human figures are sufficiently differentiated to appear as individuals. In this scene, the women and children of the village join in. The painter has not included any background to distract the eye from this hive of industry, where five stages in the handling of the harvest are depicted. The women, accompanied by their children, thresh the grain. It is hard work, but clearly a happy family time too: one woman has stopped to feed her baby, while her older toddler reaches up confident arms, and her neighbour turns her head to smile at them. Above, one of the men winnows the grain, and to the side we see three stages in the loading up the grain and carrying it to fill the granaries.

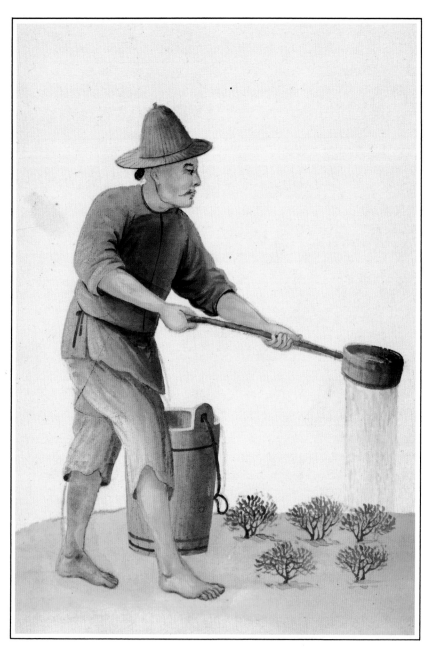

◁ **Watering Tea** (c1796)

ANOTHER MAJOR CHINESE
AGRICULTURAL PRODUCT, painted
in Westernized style for the eyes of
outsiders. This sturdy peasant is
one of 28 costume studies painted
on commission for an English
buyer. Eight of these depict
workers in the tea trade, both male
and female, at different stages
from cultivation to processing,
complete with their tools of the
trade. Created specifically to
satisfy curious Western eyes, the
paintings owe very little to native
Chinese tradition. This is notable
in the figures' poses and their
facial features, but even more in
the complete absence of life in the
picture. This study is nothing
more than a flat statement of what
the tea worker's clothes and tools
look like, painted with accuracy
and nothing more. It has none of
the abundant liveliness of the Yuan
Dynasty paintings of rice culture
(pages 64 and 65), which are
equally informative in content
but capture the spirit as well
as the surface.

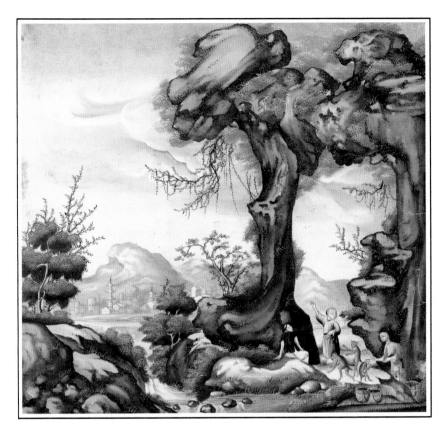

△ **Monkeys Picking Herbs** (c1780–1790)

FROM 1780 ONWARDS, Canton painting workshops churned out sets of export pictures showing stages of production in China's three major industries: tea, porcelain and silk. Believe it or not, this delightful little extravaganza purports to be a study of the tea trade. It is part of an album illustrating 23 stages in the cultivation and preparation of tea. The tea workers, two men and a woman, are directing their team of trained monkeys up the rock to gather rare herbs to flavour the tea. Far from the commonplace reality of harvesting herbs from the herb garden, this is pure fantasy, designed to meet Western preconceptions of the exotic Orient. Equally fantastical is the landscape, replete with all the trimmings of waterfalls, decorative trees, pagodas, far mountains and that splendid rock arch apparently defying the laws of gravity. Despite the self-consciously 'Chinese' content, the whole composition, perspective, colouring and style of painting are adapted to gratify perceived Western taste.

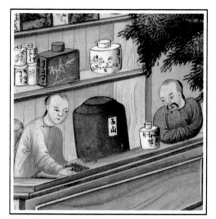

Detail

▷ **Tea Retailer** (c1780–90)

ANOTHER PAINTING FROM THE SAME ALBUM (see page 67) depicts two European merchants buying tea from a Chinese retailer. Once again, the painter is supplying what his Western customers expect: not the reality of a massive commercial enterprise, but an exotic little scene depicting the quaint customs of foreign parts. The understated, economical Yuan Dynasty drawings of villagers engaged in rice cultivation (pages 64 and 65) are full of life and the sense of labour.

In contrast, this dainty study takes a large-scale industry and creates a static scene. It is peaceful, calm and prettified. The cast of thousands employed by the trading houses, and all the bustle of big business, are represented by five figures posing languidly in their decorative little shops, waiting on a mere two customers. Time has lent the picture a period charm, but, like much export art, it panders to the buyers' desire for exotica at the expense of both surface realism and spirit.

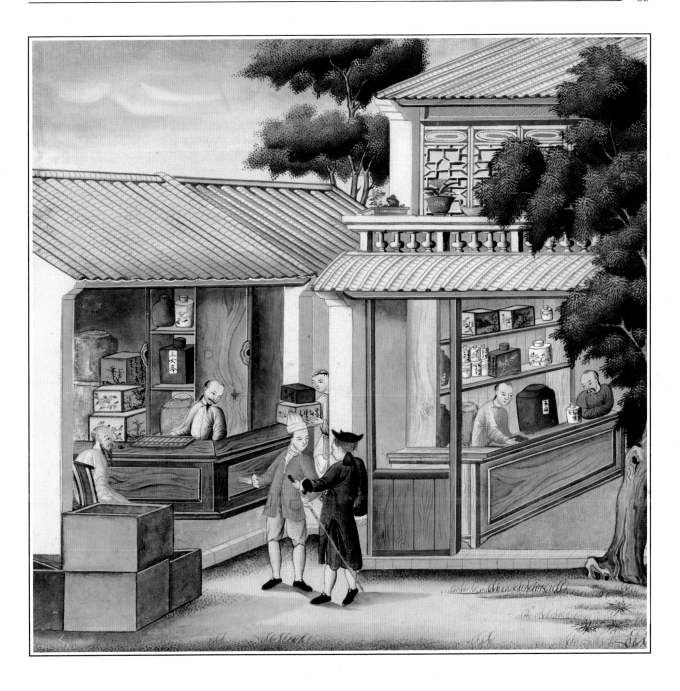

◁ **60th Anniversary Scroll**
Ku Chien Lung

ANOTHER PEACEFUL SCENE – but what a difference! Ku Chien Lung is working entirely within native Chinese traditions of fine art. It is perhaps easier to appreciate these conventions after looking at export paintings (pages 67-69) with their adoption of alien conventions. Here we have a family gathering in a garden. The mood is one of celebration, yet ordered and with all the tranquillity the Chinese garden is designed to cultivate. The figures, ranging from venerable old age to obedient childhood, are stylized, yet full of life. Depth of space is expressed by the convention that subjects higher up the scroll are further away. In comparison, attempts at western-style perspective in previous pictures seem fussy and cluttered. The perennial pine trees symbolize faith, fortitude and virtuous principles, while the vase of camellias carries the message of prosperity and long life.

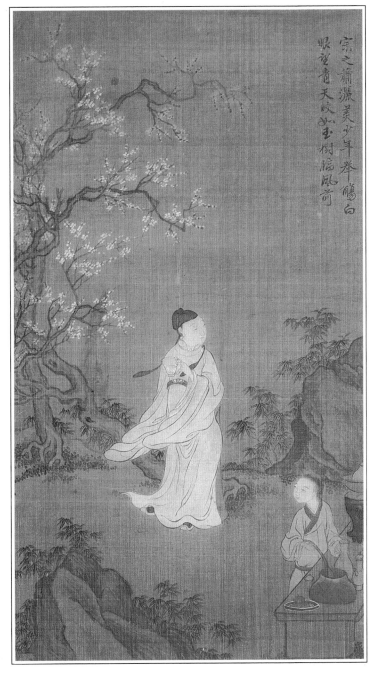

◁ Gentleman Drinking Wine
(1850–1900)

A CONTENTED-LOOKING GENTLEMAN enjoys two pleasures of the civilized life at once by taking his wine in the garden, while his attendant stands ready with ample refills. It is wintertime, and he has come out to enjoy the plum blossom. The plum, the only tree that flowers in winter, is celebrated as one of the Four Paragon plants, along with the bamboo beneath it, which also retains its beauty in this season. The treatment of the tree is conventional, appreciating its rugged trunk and crossing branches. This idyllic little scene is painted in ink and watercolour on silk, a tricky medium which requires treatment with alum and glue before use to make it less absorbent. The choice of painting surface has considerable impact on the style of brushwork to be used: the treated silk dries quickly, and is therefore suitable for sharply defined strokes with a lightly laden brush. Silk is also popular for colour-based rather than monochrome painting, for it will take stronger colours.

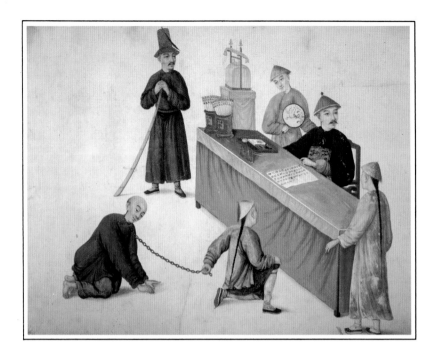

△ Scene from An Album of Punishments (1800s)

WESTERNIZED FACIAL FEATURES and body postures tell us that this is another depiction of Chinese life made specifically for foreign buyers. A chained malefactor kneels before the judge, while the constable with his tall hat and heavy staff waits to hear the sentence. Costumes and accoutrements are painted accurately, but the crowded courtroom itself, with its horde of complainants, witnesses and all the rest of the audience, has vanished in the interests of a tidy picture. Chinese justice was harsh, and the poor wretch kneeling before his judge is unlikely to get off lightly. Depending on his crime, he might be executed, imprisoned or beaten (with varying degrees of severity) with a bamboo stick. For more severe crimes, Chinese legal tradition demanded 'collective punishment', extending to the offender's close family – male relatives being executed, females sold into slavery – in order to eradicate all 'evil seeds' once and for all.

▷ Interior Scene (c1820–40)

THIS SCENE COMES from an export album of 50 paintings of Chinese domestic interiors and garden scenes. While it owes more to the conventions of Western genre painting than to native art traditions, it depicts the privacy of a Chinese room with charming, and accurate, detail. Two ladies, in their graceful silk robes with embroidered hems and sleeves, chat on a bed, while a little girl pauses in the doorway. Note their tiny bound feet, 'lotus feet' to their lords and masters, misshapen 'pigs' trotters' to Western eyes. The hanging scroll on the wall, a monochrome ink painting of plum blossom, flanked by calligraphic scrolls with poetic couplets, offers the opportunity for contemplation and will be changed from time to time. In the same spirit, the room contains two delicate flower arrangements in blue vases, and a miniature garden in a ceramic trough, while the window gives a view of waving branches in the garden outside.

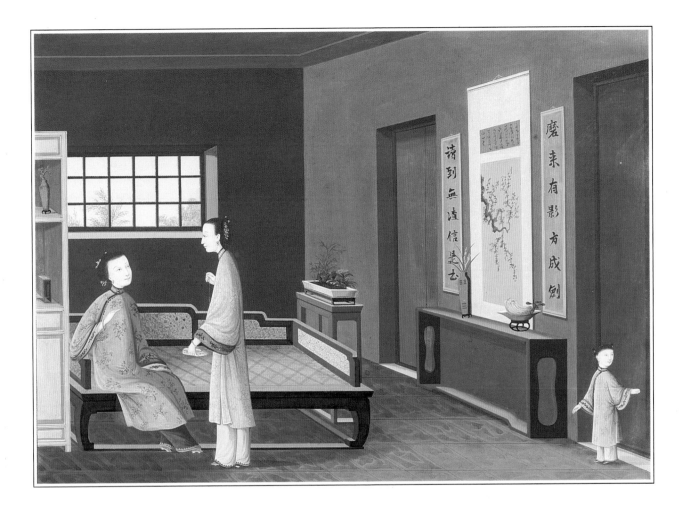

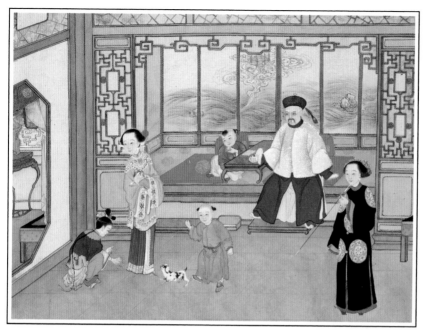

△ **Domestic Scene with Children Playing** (c 1860)

HERE WE HAVE another export painting of life in the Chinese home. This time the whole family is at home, and in relaxed mood. Their fine clothes and furnishings tell us that they are extremely well-to-do. Elaborate screens surround the window seat where the youngest child is enjoying an apple. Beside him the father, with his peacock feather in his hat as a badge of rank, presides benignly over all. One of his ladies draws on her elegant long pipe, while the other joins the children in playing with two little Pekingese dogs. These are real 'sleeve dogs', so called because they were small enough to be carried in the big sleeves that served instead of pockets. Highly treasured, they were not for export and did not reach the West until the sacking of the Summer Palace in 1860, when five palace dogs were captured by British soldiers.

▷ **Marriage Procession**
(detail) (c1840-50)

IN THE PERIOD when Cantonese workshops were concentrating on export paintings in westernized style, painters in districts farther afield stuck more closely to native traditions. This scene comes from an unusual set of watercolours from Ningpo which has been described as not truly export art, but native popular art which happened to be exported. Showing minimal Western influence, these pictures seem to reflect a local style of Chinese popular painting – not fine art, but produced for the pleasure of a wider native audience. This example shows a rather grand wedding procession. The bride is carried, hidden from sight, in her ornate sedan chair by four red-jacketed military officers whose insignia denotes their rank. She is followed by her attendants bearing her dowry, which includes a pile of quilts and pillows. Four further paintings of the wedding procession are included in the set: once they would have been produced as a continuous handscroll rather than as separate scenes.

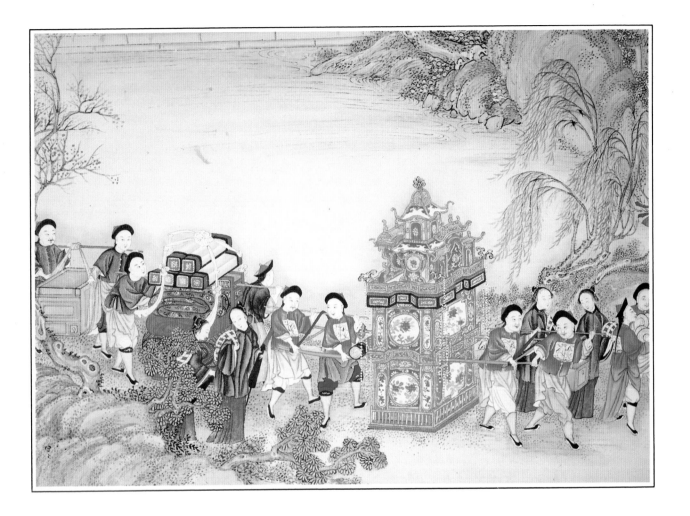

▷ **Mandarin** (c1860-80)

FROM A CANTON EXPORT WORKSHOP, this picture comes from a set of 10 portraits of dignitaries and warriors. It is painted with meticulous care and detail. The richly embroidered robes, carved furniture and vessels on the table give the impresssion of accurate observation. It is unlikely that the buyer would have realized that the subject of the painting is a purely imaginary figure! While pretending to portray a real official, the painter has created a fantastic figure designed to please and impress an uninformed foreign audience. His make-believe mandarin sits, as no mandarin sat, in the posture of a Buddhist monk to add to the fake-Oriental atmosphere. He boasts an unlikely medley of costume and accoutrements – the floral roundels that adorn his robe are those of female dress. Deliberate misrepresentation on the part of the artist conceals the real China from the uncomprehending foreigner, without descending to the contemptuously slapdash style of the picture opposite.

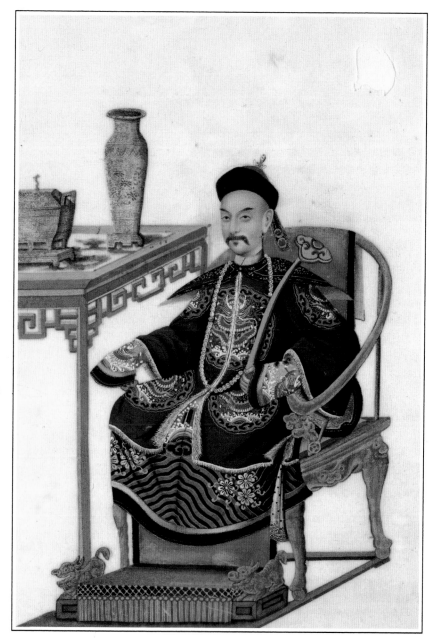

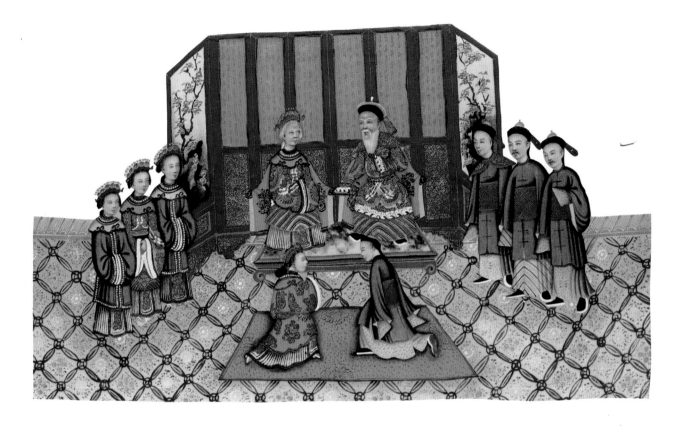

△ **A Wedding** (c1900)

WE END OUR TOUR of Chinese watercolours with a turn-of-the-century degradation of a fine tradition. Export painting reaches its nadir with this later study of a wedding scene, from a series painted in a Canton workshop. Here the bridal pair are shown kneeling before the groom's parents. In a previous picture (page 75), the artist paid punctilious information to the details that would tell his Chinese audience exactly what was going on. No such care has been taken here: the export artist is producing a colourful bit of exotica for ignorant foreigners to admire. Sketchy draughtsmanship, caricatured costumes, garish colours, and the positively horrible, sloppily sketched carpet design are quite good enough for the 'foreign devils'. This is not so much the descendant of ancient Chinese tradition as the direct ancestor of the cheap and cheerful paintings sold today to tourists in Hong Kong.

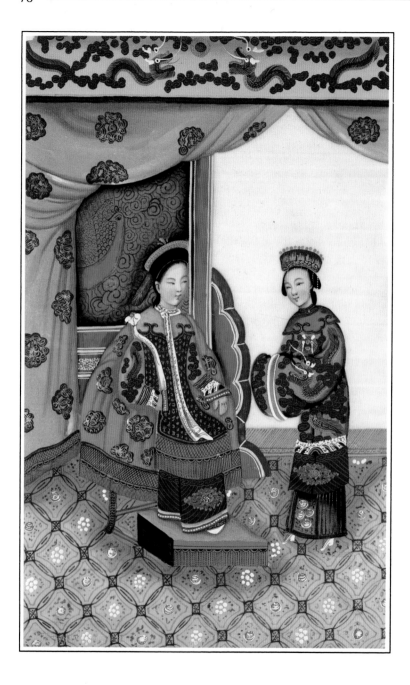

◁ **Empress** (c1900)

FROM THE SAME SERIES as the picture on page 77, and painted in the same spirit, comes this most unrealistic painting of an 'Empress'. The doll-like figure in her fancy dress bears no resemblance to the powerful Dowager Empress Tzu Hsi who ruled at that time. No attempt has been made at accurate representation – she has even been painted wearing a man's hat! A certain lack of imagination on the part of the artist is shown by the reappearance of the crudely drawn carpet of the wedding scene, now accompanied by some depressingly perfunctory dragons slapped on to decorate the hanging at the top of the picture. Such paintings were mass-produced, sometimes by tracing from printed outlines, then colouring in. 'Tourist art' like this represents a cynical, and presumably profitable marketing exercise and has little to do with Chinese art theories and techniques.

ACKNOWLEDGEMENTS

The publisher would like to thank the following for their kind permission to reproduce the paintings in this book:

Bridgeman Art Library, London/Victoria & Albert Museum, London: 8-9, 11; /**British Library, London**: 22, 23; /**Chester Beatty Library & Gallery of Oriental Art, Dublin**: 24-25; /**Lindley Library, Royal Horticultural Society, London**: 30-31, 32-33; /**Chester Beatty Library & Gallery of Oriental Art, Dublin**: 38-39, 40-41; /**Private Collection**: 42-43, 46; /**Bibliotheque Nationale, Paris/Giraudon**: 56

E.T. Archive, London/Nelson Atkins Museum, Kansas: 10; /**Freer Gallery of Art, Washington D.C.**: 12-13; /**William Rockhill Nelson Gallery, Kansas**: 16; /**Bibliotheque Nationale, Paris**: 20-21; /**Victoria & Albert Museum, London**: 26-27; /**National Palace Museum, Taiwan**: 44; /**William Rockhill Nelson, Gallery, Kansas**: 45; /**Cleveland Museum of Art, Cleveland, Ohio**: 52-53; /**British Museum**: 54-55; /**National Palace Museum, Taiwan**: 57; /**Musee Guimet, Paris**: 60-61; /**Freer Gallery of Art, Washington D.C.**: 62-63, 64, 65; /**Private Collection**: 70; /**Berry-Hill Galleries, New York**: 72; /**Victoria & Albert Museum, London**: 75

Courtesy of the Trustees of the Victoria & Albert Museum, London: 17, 18-19, 28-29; /**Photographer: Ian Thomas**: 34-35, 36-37, 47, 48, 49, 50-51, 58-59, 66, 67, 68-69, 71, 73, 74, 76, 77, 78

Every effort has been made to trace the copyright holders and we apologise in advance for any unintentional omissions. We would be pleased to insert the appropriate acknowledgement in any subsequent edition of this publication.